Life Lessons

Get along with people in a more loving way.

"Chase life" by reinventing yourself daily.

Add joy to life by creating your own sunshine.

Appreciate everyone and everything deeply.

Create a change within you.

Never stop learning...

Written by Kay Hirai　　Edited by Kristen Anderson　　Graphic design by Ross Hirai

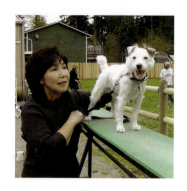

This book is dedicated to my special terrier Yumi.

Yumi was a feisty and intelligent Jack Russell Terrier. Yumi gave me many gifts...she made me a better human being. She taught me lessons daily by her actions.

I want to share Yumi's teachings with you. I hope that sharing them will make us all more lovable, as Yumi taught me.

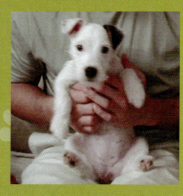

August 20, 2001 – December 16, 2005

" A good friend once told me, Kay, you learned so much from Yumi, because you were ready to be a student. A teacher appears only when the student is ready to learn. "

Lesson 1 Less is Best

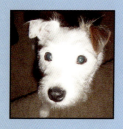

The Lesson:

When I picked up Yumi, I must admit that I was disappointed. I was visualizing a typical Jack Russell Terrier with tri-colored markings of black, brown and white. Yumi was all white with one brown ear. It was obvious that she was the runt. She was not as chubby as her siblings, and always sat off to the side while her sisters and brothers romped and played with each other.

Bringing her home, I wondered if I could learn to love this plain white terrier with no markings on her body. As time went on, I began to appreciate her simplicity. Her almond-shaped eyes and shiny black nose stood out like little jewels against her white fur. The burgundy patent leather collar I placed around her neck gave her the appearance of a million dollar dog.

I began to appreciate Yumi's subtle and simple beauty, until it affected everything else I did in life. I removed the clutter from my home and my place of business. I developed an appreciation for simple art and music, and began to enjoy the simple things in life such as walking in the park and in woodsy areas.

I would often tell Yumi "You inspire me to do and enjoy the simple things in life."

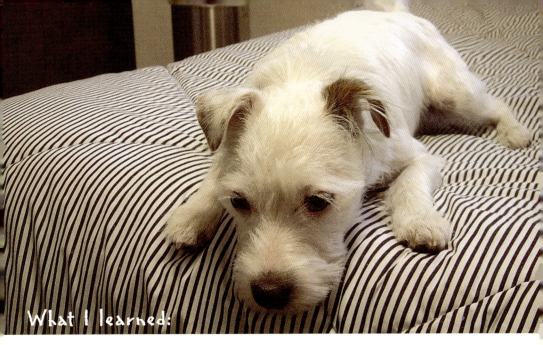

What I learned:

- Going for early morning and evening walks with Yumi taught me to enjoy nature which surrounds us. I began to appreciate the leaves, branches and shrubs that Yumi examined and sniffed so carefully.

- Reducing the clutter in my home and office keeps my energy flowing and keeps me moving forward.

- I learned that I enjoy going out into country environments. It's amazing how this shifts my thinking from the usual routine, and clears my mind to receive new ideas.

- I realized that I enjoy being around people who are not from my realm of life. It's fun to go for walks at Marymoor Park and strike up conversations with strangers about our dogs.

- Every time I have to make an important decision in my life, I remind myself "Keep it simple…less is always the best."

Lesson 2 You are My Sunshine!

The Lesson:

Mornings were Yumi's favorite times. When I heard her soft whimpering, I would let her out of her kennel. She would immediately find Senna (our Chihuahua) and overwhelm him with her playful dance and "lick, lick, licks" on his face. Senna would growl, since he found her to be a total nuisance. After saying "good morning" to Senna, she would run into the bedroom and do the same to me.

After her hip-shaking dance, licks and jumping, she was ready for her morning walk. She would follow me around the house and give me a soft nudge behind my knees. I would think to myself, "Yumi is so smart… she knows how to put us in a good mood first so that in turn, we will have a good attitude about going for a walk with her."

I took her for her morning and evening walks regardless of the wind, rain or cold. Because of my good mood, I came up with lots of great ideas during our walks. When I shared my ideas with others, they would ask, "Where did you get this idea?" I would reply "Yumi gave it to me!"

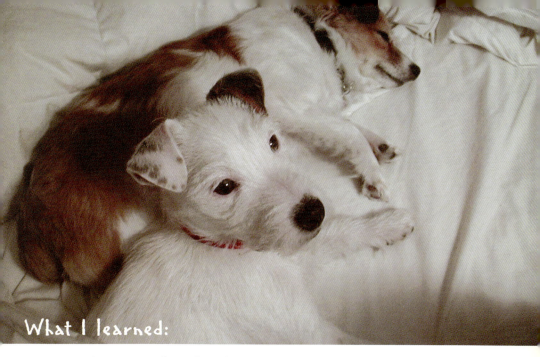

What I learned:

- We receive a better response from others when we put them in a good mood first. Our first encounter with another human being in the morning, whether it's our spouse or our coworkers, will set the tone for the day. We have the power to create a day filled with sunshine or a gloomy day without laughter.

- If you give people more than they expect and go the extra mile, they will reciprocate with the same giving attitude.

- Don't take on another person's negative energy. Yumi didn't pay any attention to Senna's growling when she licked him and played with him. She was still her same old happy self.

- Watch your voice tone and body language when you approach people. Have a smile on your face and be open with your body gestures. We may not be able to do the "hoola dance" like Yumi, but each of us can find ways to brighten other people's days.

Lesson 3 Leadership- It All Starts with You

The Lesson:

Yumi began her life with the label trainers often give to Jack Russell Terriers: "bad dog". I finally found Katie Morrell, who is an "expert" in training the incorrigible terrier breed. Yumi and I drove to Redmond for our weekly classes with Katie. It did not take long before I realized that it was not Yumi who was in training. It was I, the owner, who was being trained to be a good leader.

Whether in obedience or agility classes, it was always the same message: "If your dog does something incorrectly, don't scold the dog. Instead look introspectively at yourself." It was not much fun when I was busy blaming Yumi for not obeying my commands, and the trainers would tell me "It's not Yumi's fault. She is reacting to your poor leadership skills."

As handlers, we were forced to ask the following questions: How did I give the command? How was my body positioned? What did my facial expression and tone of voice reflect? Was I upbeat and exciting when I worked with my dog? Basically it boiled down to "What kind of leader am I?"

What I learned:

- I found it amazing that classes in obedience and agility taught me skills to be a great leader. I think that people who desire to improve their communication skills would benefit from taking dog obedience and agility classes.

- When dogs go through obedience training, their confidence level rises…and it is no different for us. The more we learn, the more confident we become.

- Keep it simple! When we speak to others and when we write, we should use simple words and phrases, and cut out all the extra words that are not necessary. Don't squeeze too much in.

- Give feedback to others. No one will know if you aren't pleased unless you tell him or her in a nice way. Without feedback, we won't grow.

- Gain loyalty and trust by being genuine, compassionate and truthful. Yumi always knew when someone was not genuine and kind… she would not warm up to them.

Lesson 4: If You Aren't Scared, You Aren't Growing

The Lesson:

I will always remember our first day at Agility class. Yumi and I were both scared stiff. Agility was something new to us - I had watched it on television on the Animal Channel.

Yumi was scared out of her wits when we walked into the agility training center, which was 3,000 square-feet of sawdust with giant equipment and obstacle courses. She was the only pint-sized dog among larger dogs that were five times her size in stature and weight. As Yumi and I stood at the starting line facing our first obstacle, I could see her little terrier body trembling with fear. I remember giving her a gentle pat on the head and whispering in her ears "Yumi, I know you're scared but wait and see, we can do it."

During the next 18 months, with consistent coaching from our trainer Karen Blumenthal, Yumi and I made progress in small, incremental steps as she mastered the obstacles one by one. At the end of each run I would say "Yeah, Yumi, you did it. Good girl!"… She would look at me as if to say, "Ok, where's my pay?", and I would reward her with a double dose of her favorite treat.

Our proudest moment was when the owner of the agility center came by and said, "Yumi, you have come a long way. You can now live your doggie life with more confidence!"

What I learned:

- We can get stuck being comfortable in life. Always ask, "What's my next level of growth?" and go for it. You will be surprised by what happens to your energy when you open a new door.

- It is scary to try something new, no doubt. Always remember that growth does not come without pain.

- Grow in small steps. Mastering one thing before going on to something new will help you to stay focused. Practice Kaizen, a Japanese word for life-long learning in small, incremental steps.

- The journey to growth is more fun if you don't do it alone. Find a good coach, mentor or friend who will walk with you.

- When you master something new, reward yourself and others with treats and praise. Savor the glorious feeling of success!

Lesson 5 Test of Will

The Lesson:

It took three and half years before Yumi and I began to work as a team and exchange mutual respect and admiration for each other. My friends loved to hear about Yumi's antics: shaking down a bird's nest to play with the baby birds, running into the pond area to chase the ducks, and burying a pile of my personal belongings in a hole she had dug for her treasures.

When I scolded Yumi for her bad behavior, she would look at me with her innocent almond-shaped eyes, her head cocked to one side...her face covered with dirt. I interpreted this gesture as "What did I do wrong?"

Yumi's trainers helped me to understand that she was born to work, and that her work was to hunt, bury, dig and chase. When I accepted Yumi for what she was born to do, understanding followed. I learned to work with her on her own terms.

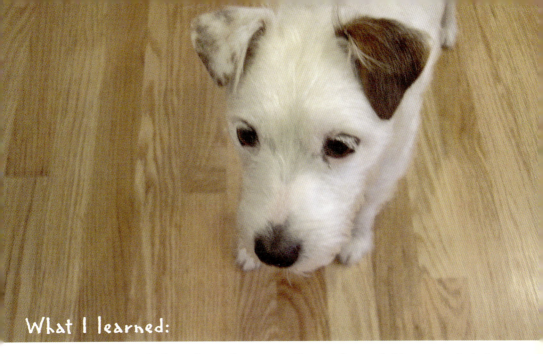

What I learned:

- Don't put your own standards on others and expect them to feel, see or do as you do. We must first seek to understand the person's mission in life. Once we discover their mission, getting along with them becomes easier.

- Conflict is a good thing—it's a starting point where we can reach a mutual understanding. Getting on the same page with someone creates a powerful synergy, which is much better than working by yourself!

- If you are frustrated with someone, don't give up. Try to find another doorway to keep the communication flowing.

- Be the first to reach out…and keep reaching out. Never give up.

- It's easy for us to take things for granted and expect people to do the right thing. Don't forget to say "I like what you did - thank you!" each and every time.

Lesson 6 Commitment and Discipline

The Lesson:

Before I brought Yumi into my life, I spent a year researching the Jack Russell Terrier breed. I learned that this breed is intelligent, high-spirited, humorous, and has boundless energy. I also found out they are strong willed, persistent and easily bored.

I wanted to make sure that I could commit to raising such a dog. My ability to provide daily exercise and consistent discipline was critical to my success as an owner. My schedule was already overloaded with running two businesses. I wondered if I would be able to make the time commitment to raise Yumi, which meant daily morning and evening walks, ongoing obedience training and play times at the park.

I am proud to say that I learned how to manage my time to include the daily activities for Yumi and me. I became more efficient in everything I did so I would not have to skip my time with Yumi.

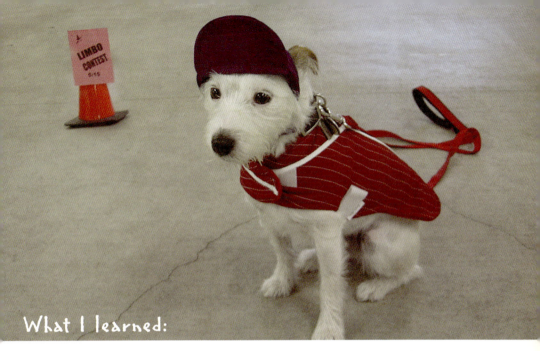

What I learned:

- Most of us only give 20% of our capabilities every day. Just imagine how much we could accomplish if we gave 100% to everything we did.

- Adding discipline to my life made me feel good about myself. This means "just doing it", even though I really didn't feel like it at times. Our daily walks forced me to get the daily exercise I needed for my own well-being!

- As I put more structure and consistency into Yumi's daily routine, my life became more organized as well.

- The more loving attention I gave to Yumi, the more trust and loyalty she felt towards me. Just imagine how much trust we could build with each other if we "went the extra mile" every day with the people around us.

Lesson 7 The Crouching Tiger

The Lesson:

I remember the wonderful afternoons our family spent walking and running at Marymoor Park. Yumi loved to go there. She would get caught up in the excitement of having freedom, and at the same time she was anxious and nervous about all of the big dogs that might chase her.

Yumi tried to show bravery by positioning herself low to the ground like a crouching tiger, and giving a low growl. Many owners of the larger dogs would chuckle and laugh at this little pint-sized Jack Russell Terrier who positioned herself in an attack mode.

The larger dogs would sense her show of bravery, and come running up to her in threes and fours. Yumi would immediately get up, assume a submissive position, and sometimes have a diarrhea attack right on the spot. The large dogs soon realized that it was just a false front and they would trot away.

What I learned:

- Power does not lie only in the biggest companies, richest individuals, or strong dominant figures. A small person has just as much power if he or she would only remind themselves that "I am somebody and I am important."

- As a small business owner, I used to feel inferior to the large companies who exercised their muscles like a 500 lb. guerilla. Now I am able to appreciate the difference my small business can make in the lives of our employees and our community.

- When someone gives me a compliment, I can now say "Thank you!" rather then make excuses about why I don't deserve such a compliment. Think how often we put ourselves down instead of accepting praise from others.

- When I get backed into a corner, I try to remember how Yumi showed her bravery. Stand firm and face the challenge rather than run away.

- I learned to always be light on my feet and ready for the changing wind…knowing that its direction can change at any time without a moment's notice.

Lesson 8 Generous with Affection

The Lesson:

Yumi greeted me with boundless enthusiasm every time I came home, as though I was the only human being on this earth. I had to open the door very carefully as I entered the house because the first thing that peeked out from the crack of the door was her black button nose. No matter how late at night, she never failed to perform her "I am so happy to see you greeting dance"…with swinging hips, the wagging tail and her circling dance.

She did this dance during her last few days at the vet hospital when she was sick and weak. Using every last bit of her terrier energy, she greeted me with the usual hip-swinging, tail-wagging welcome (with the IV tubes flopping around), until she became so weak that she had to flop down.

I will always remember Yumi's black button nose and her soulful eyes. What an enthusiastic, right-in-your-face friend she was!

What I learned:

- Greet everyone with a friendly gesture and a warm smile. A smile on your face will light up the room.

- Give more hugs throughout the day to show people how much you appreciate them.

- Never take the people around you for granted, or forget how much they mean to you. Praise them for something they do right.

- Don't focus on yourself and your own problems. Instead, be the same champ Yumi was. Even when you're not feeling up to snuff, enthusiastically show people how happy you are to see them.

- Give people more than they expect in everything you do. Kind words and humor are like a healing tea…a fuel to give people a lift during a rough day.

Lesson 9 Treasure Good Friends

The Lesson:

Yumi and I acquired many good friends during her four short years on this earth. I was so surprised by how many people reached out to me during Yumi's illness. Even more, I was surprised and grateful for the outpouring of support in the months that followed. I was able to talk and share my feelings with friends who cared about me. When you don't feel alone during the peaks and valleys of life, the process becomes easier and even joyful in spite of your sorrow.

What I learned:

- When others are going though hard times, we often don't reach out due to our own feelings of awkwardness. It's human nature to avoid things that feel uncomfortable. I learned how important it is for us to reach out to others who are going through hard times.

- We are surrounded by friends, acquaintances and co-workers who are facing personal issues and challenges. Keep your eyes and ears open for wounded hearts, and offer friendship by listening to their feelings and offering words of wisdom.

- Rather than concentrate on the negative side of events, help people see the brighter side. Learning the skill of "thinking out of the box" can help others (and ourselves) see situations in a different light.

- Don't dwell on the past. Move forward towards finding solutions and possibilities. It's amazing how we can direct our minds to think in new channels with a little help from a caring friend.

- Be discriminating when you need support from others. Seek counsel from friends who have a positive outlook on life, and stay away from people who drag you down with negative thoughts.

Lesson 10 Learning Takes Place when the Timing is Right

The Lesson:

I wonder why I learned so much from my time spent with Yumi over the past four years. Was she an exceptional terrier who was wise beyond her years? Or did it have to do with me having an open mind to accept the lessons she taught and acquire that wisdom? I will never know, but deep in my mind, I think it had to be a combination of both. My four years of living, teaching and playing with Yumi came at the right time of my life.

I believe that once we reach the top of one hill, we start again at the bottom of another hill…Yumi came to me when I stood at the bottom of the hill looking up. I was ready to climb forward to continue my process of life-long learning, the Kaizen. This all happened at the right time of my life.

What I learned:

- Learning does not always take place in the classroom or from reading a book. We often learn simply by experiencing life. Having an open mind to reflect on the lessons and glean wisdom will help us to live better lives. There will be no gain unless we go through pain.

- You can go through a similar learning experience at another time in your life, but if the timing is not right (if your mind is not open to learning), you may walk away without learning anything.

- We all face countless peaks and valleys throughout our lives. We should consider ourselves very fortunate when we encounter the right experience at the right time in our lives. We may have an "a-ha" moment!

- Remember that "when one door closes, another door will open," bringing light and new opportunities to pursue, and keeping us on the track of forever learning.

Introducing Max!

"It's true that we don't know what we've got until we lose it, but it's also true that we don't know what we've been missing until it arrives"

— unknown —

Max came into my life two months after Yumi's passing. He was so needy of my attention and grateful to have a place in our home, it was impossible not to get attached to this lovely little terrier. I look forward to learning and growing with Max, and wonder what lessons I will learn from him. One thing is for sure…there's never a dull moment when you live and play with a terrier!

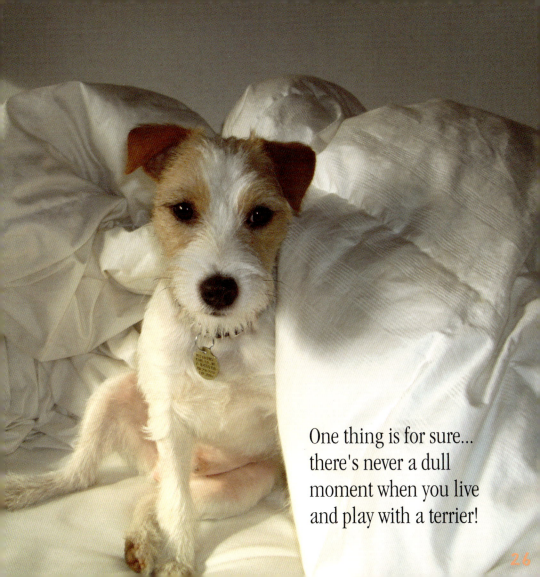

One thing is for sure... there's never a dull moment when you live and play with a terrier!

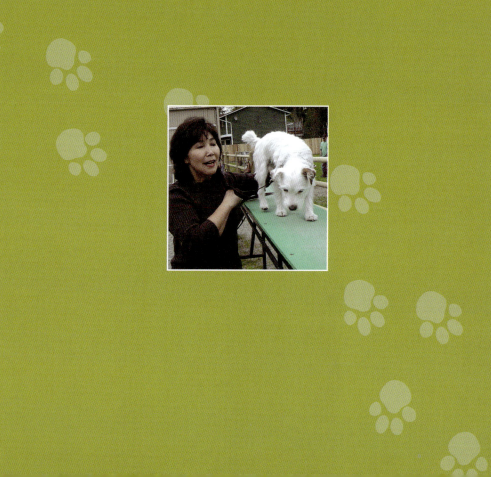

About the author...

Kay Hirai is president of Seattle-based Studio 904 Salons, an innovative small business with 25 employees that is nationally known for its hiring practice, employee training and community outreach programs.

Inspired early in her career by Kaizen, a Japanese word that means life-long learning in small incremental steps, Hirai has applied this philosophy to guide her company since its inception in 1987.

Hirai views her business as a vehicle to give back to the community and ultimately make a difference in the lives of her clients, her employees, and in the communities her salons serve.

She hopes that Yumi's Life Lessons will help promote humane treatment of animals, and that it will motivate others to help animals that desperately need a home, love and attention.

" Through this gorgeous little book, Kay's dog Yumi inspires us all. I suspect that the life lessons Kay shares in it were not only learned from her charming Jack Russell terrier, but also from her years as a successful and innovative business leader. A great gift for family, friends and acquaintances. "

-Marianne Scholl, co-founder and publisher of Seattle Woman magazine